PRESTON

HISTORY TOUR

ABOUT THE AUTHOR

Keith Johnson is Preston born and bred. His previous works include the best-selling *Chilling True Tales* series of books featuring Preston, Lancashire and London, and the popular *People of Old Preston, Preston Remembered, Preston Through Time, Preston In The 1960s, Secret Preston* and *Preston In 50 Buildings*.

Keith was educated at St Augustine's Boys' School in Preston prior to attending Harris College, where he gained his qualifications for a career in engineering – spending forty years working for the printing press manufacturer Goss.

First published 2017

Amberley Publishing
The Hill, Stroud,
Gloucestershire, GL5 4EP
www.amberley-books.com

Copyright © Keith Johnson, 2017
Map contains Ordnance Survey data
© Crown copyright and database right
[2017]

The right of Keith Johnson to be identified as the Author of this work has been asserted in accordance with the Copyrights, Designs and Patents Act 1988.

ISBN 978 1 4456 5765 3 (print)
ISBN 978 1 4456 5766 0 (ebook)

British Library Cataloguing in Publication Data.
A catalogue record for this book is available from the British Library.

Origination by Amberley Publishing.
Printed in Great Britain.

ACKNOWLEDGEMENTS

I must acknowledge the help given to me by the staff of the Harris Community Library in Preston, who willingly assist as I delve into their archives. Their records of the past make my research that much easier.

Besides my own collection of images and illustrations, I would like to thank the *Lancashire Evening Post* for permission to use images that are nowadays stored in the Preston Digital Archive. Also, my thanks go to Richard H. Parker, the creator of the PDA, for use of images from that source and to Mike Hill, communities editor of the *Lancashire Evening Post*.

My thanks also to Pat Crook for cheerfully checking my text and putting her literary skills at my disposal once again.

INTRODUCTION

Historian Anthony Hewitson had this to say about Preston in his *History of Preston*, published in 1883:

> The town of Preston occupies an elevated and beautiful position, immediately adjoining and on the northern side of the river Ribble. Viewed from the South, the town has a stately, handsome appearance; and its environments are equally pleasing. In front there are charmingly laid out public parks; to the right, there are pretty vales and wood crowned eminences; leftward, the Ribble winds along its way to the sea; while the background is filled up with dark purple, undulating hills.

In those days it was very much a cotton town, with factories and tall chimneys having replaced the windmills and weaving sheds of earlier generations. The population had risen from around 5,000 at the dawn of the nineteenth century to over 90,000 some eighty years later. Industry

flourished in Preston well into the twentieth century with great engineering skills at the forefront of technology; there was textile machinery, motor vehicles, trams, railway carriages and motive power, aircraft, printing presses and even gold thread coming off the Preston production lines.

It became a town that developed its 'Priests Town' tag by the building of numerous churches and chapels and, with the increased diversity of the city in recent decades, a significant number of mosques and temples have appeared.

The cotton workers certainly had a thirst to quench because by late Victorian times hundreds of public houses had appeared on the landscape. Public parks in abundance nurtured the recreational side of life in Preston and places of entertainment have flourished down the years, leaving older folk with fond memories of their earlier years.

Transport has also played a significant role in Preston, from those early stagecoach and horse-drawn carriage days that eventually led to electric trams, automobiles, motor coaches and buses, all of which have ferried folk around Preston and beyond.

Fortunately, education was always a primary objective from the city's early days, be it from grammar schools, church or ragged schools. With local folk keen to learn, this would eventually lead to the growth of the Harris Institute into the ever-expanding campus of the University of Central Lancashire, which plays such a prominent part these days. Indeed, the cotton town, made into a city in 2002, has now become a university city and continues to steadily grow with a population of over 114,000. Preston also remains at the heart of the administration of Lancashire, with County Hall still flourishing.

Always remember that this old town endured feast and famine, plague and pestilence, triumph and tragedy, and conflicts and confrontation to emerge as 'Proud Preston', a title richly deserved.

Hopefully, this history trail will give you a glimpse of Preston's past and the endeavours of its people. A chance to wander and wonder where generations past have lived and toiled down the years. The streets and alleyways, buildings and structures, parks and pastimes all left a legacy, although it is the people who made Preston proud.

This history tour of Preston starts on Fishergate Hill outside County Hall, weaving a winding path before concluding at the railway station – I hope you enjoy the journey.

Keith Johnson

A PRESTON HISTORY TRAIL

This trail begins on Fishergate Hill, then along Fishergate to Chapel Street. On next to Winckley Square, surrounded by fine buildings, some of which date back to the dawn of the nineteenth century. After wandering around the square it is but a short walk to the Avenham and Miller parks by the side of the River Ribble, where historical delights await. Leaving the parks, by Avenham Walk, soon Avenham Lane beckons and then a slight detour takes you to Stoneygate where Arkwright House still stands and where you can glimpse a rear view of Preston Minster.

Returning to Avenham Lane and on to Queen Street you will reach London Road, a vital route in or out of the city. At this junction, to your left, is Stanley Street, which leads you to Church Street. As Church Street turns into Fishergate, Cheapside beckons, along with the ancient Market Square. Harris Street, by the side of the Harris Museum, takes you up to the Guild Hall and Town Hall on Lancaster Road. A short walk along Crooked Lane brings you to the Preston Bus Station – from its top floor you can view Preston in its entirety. Returning to Lancaster Road the Covered Market beckons, as do Market Street and Orchard Street from where you can enter Friargate. A few steps more and you are on Lune Street, where the old corn exchange and St George's Chapel await. Next is the Ringway and a stroll towards Friargate Brow, which eventually leads to the Adelphi roundabout and the UCLAN campus. Corporation Street will then take you to where the canal once terminated, along with a return to Fishergate and our journey's end at Preston Railway Station. Hopefully, by then you will have embraced the history and the heritage of the city and its folk.

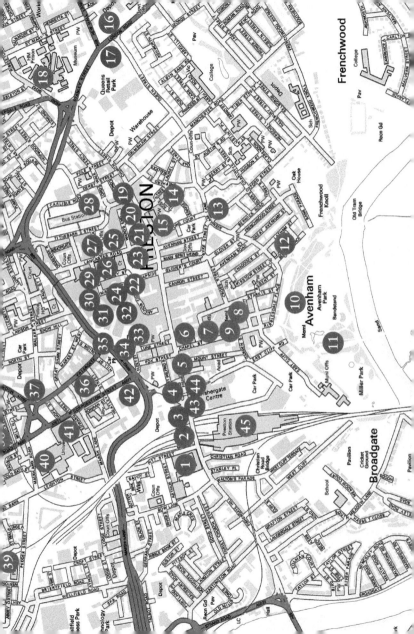

KEY

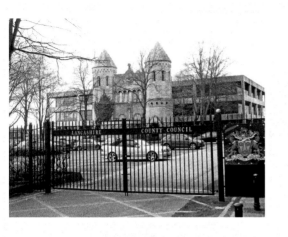

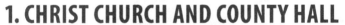

1. CHRIST CHURCH AND COUNTY HALL

Christ Church, viewed from Fishergate Hill, was built of limestone in the Norman architectural style and was consecrated in 1836. It cost £3,000 and its construction was watched over by Roger Carus Wilson, the vicar of Preston from 1817–39. The church was closed in 1970 and a dual-purpose building was constructed on the site by Lancashire County Council, thankfully the limestone towers remain. Visible through the gates from Fishergate Hill, it is at the rear of County Hall, which opened in 1882. The architect of County Hall was Mr Henry Littler of Manchester, and the cost of the structure was around £58,000, inclusive of the site. By May 1934, the meetings of Lancashire County Council were held in a new council chamber after extensive extension work, including a 160-foot frontage on Pitt Street. These days County Hall remains very much at the centre of Lancashire administration.

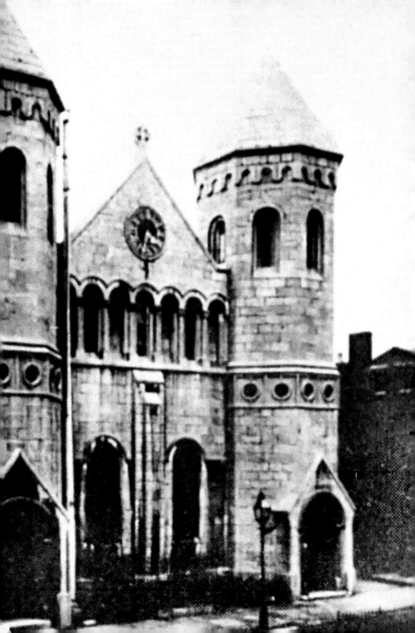

2. FISHERGATE RAILWAY BRIDGE

The Fishergate Railway Bridge, recently renovated, was under construction in 1877 to replace the Fishergate Tunnel; it was a major boost for services in and out of Preston. In the image here a Leyland Olympic, operated by Fishwick Bus and advertising Red Rose Ales, stops on the Fishergate Railway Bridge, with County Hall in the background *c.* 1956. John Fishwick moved from Wales to Leyland in 1907 and he bought a steam-propelled wagon to get into the haulage business. Within three years he was carrying his first passengers after converting his petrol-powered second vehicle to transport customers to Preston at weekends. For decades the green Fishwick fleet were familiar on Preston's streets; unfortunately, in October 2015, J. Fishwick & Sons ceased trading.

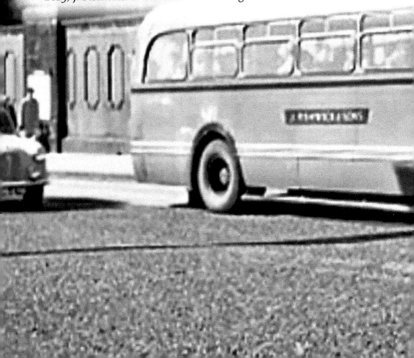

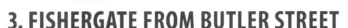

3. FISHERGATE FROM BUTLER STREET

Tommy Ball's shoe shop can be seen to the left of this 1976 photograph; a fire destroyed the building in September 1978 when it, along with the adjacent Duck Inn and the Victoria & Station Hotel, was engulfed by flames. Dating from 1838, the Victoria & Station catered for the early rail travellers. It was a first-class hotel in its day, offering sixty bedrooms and a large ballroom for hire. Happily, the Victoria & Station (now the Old Vic) emerged from its ordeal and is still a popular inn.

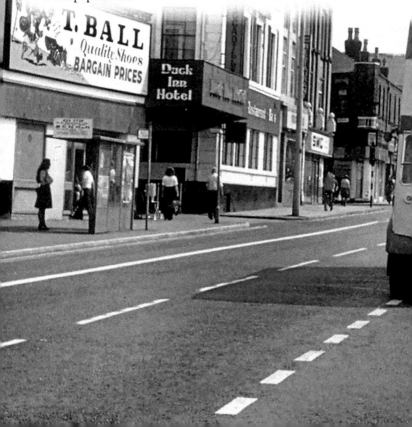

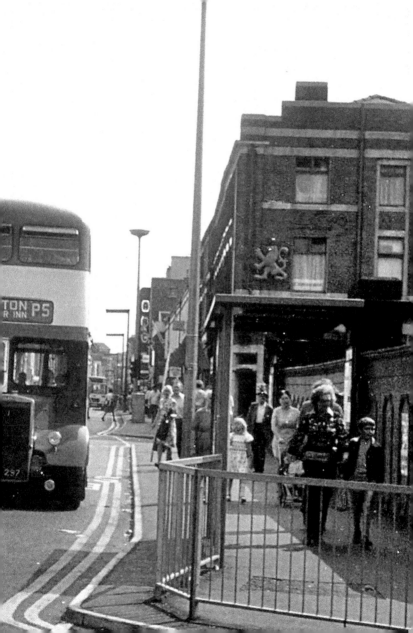

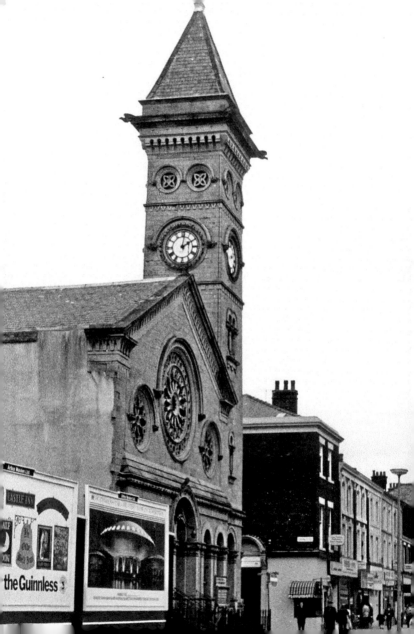

4. FISHERGATE AND FISHERGATE BAPTIST CHAPEL

Walking up Fishergate, the first thing likely to catch your eye is the Fishergate Baptist Church and its clock tower. They laid the foundation stone of this church in July 1857 and it was set to replace a chapel in Leeming Street (now Manchester Road) at the corner of Queen Street. The design was entrusted to a rising young architect, James Hibbert, who would later go on to design the Harris Library & Museum as well as other local churches. The finished building was capable of accommodating 550 people. Within three years of the opening, the four-sided clock was placed in the 110-foot-tall tower, paid for by public subscription. Although no longer used for church purposes, there are plans afoot to utilise the structure.

Fishergate, pictured here in 1982, has, in recent decades, become populated by numerous coffee shops and cafés; the most striking is still the Bruccianis café. In its location since 1932, it retains its splendid art deco interior.

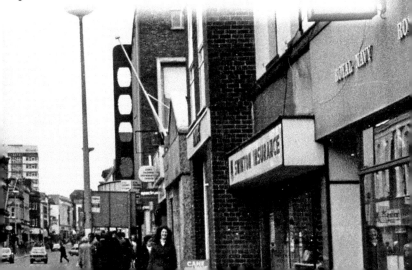

5. FISHERGATE FROM FOX STREET

This image shows a busy, bustling shopping street in the town centre. The Lloyds Bank, who took over the ivy-clad Victorian townhouse on the corner of Fox Street in 1919, eventually built a new structure four-storeys tall. Prominent on the skyline is the wedge-shaped tower of the old Preston Gas Showrooms, which opened in 1877 and was knocked down in 1964. The Preston Gas Light Company began in 1815 and, thanks to the efforts of Revd Joseph Dunn and printer Isaac Wilcockson, Preston became the first provincial town to be lit by gas in 1816. A sign points down Winckley Square to the old Park Hotel overlooking Miller Park.

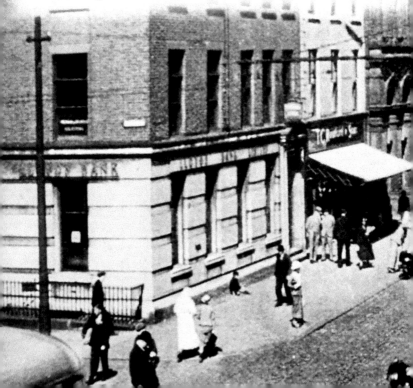

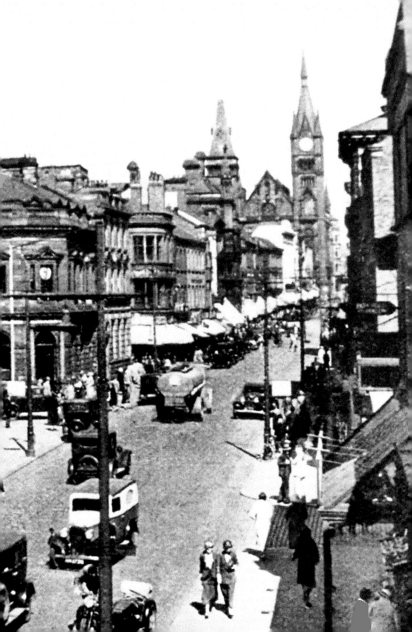

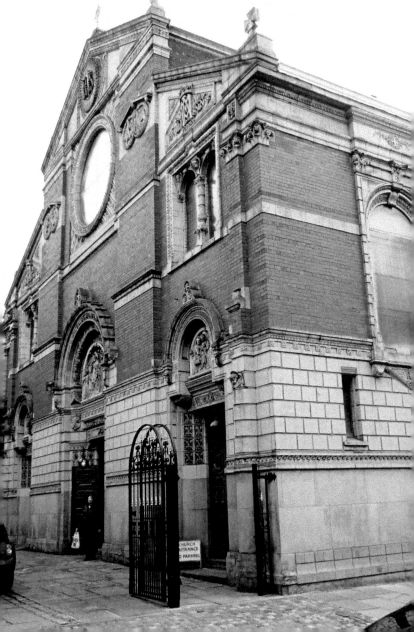

6. ST WILFRED'S RC CHURCH

Local artist Edwin Beattie produced this painting of St Wilfred's RC Church on Chapel Street in 1894, thus celebrating over a century of worship at the church. The church was first opened in June 1793, having cost £3,500, and was rebuilt and enlarged in 1843. Further renovations followed in 1880, 1892 and a baptistery was erected in 1901. The building is in the Italian basilica style of architecture. It is built in brick with terracotta cladding and dressings, and has a slate roof.

The priest whose name is mostly associated with the development of the parish, church and schools is Revd Joseph Dunn. A Jesuit priest, he was affectionately known as 'Daddy Dunn' and arrived in Preston in 1776. Father Dunn is also credited for the building of the nearby Fox Street school.

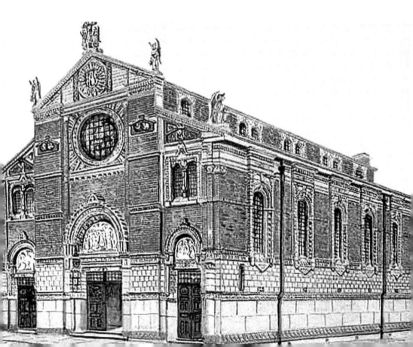

7. WINCKLEY SQUARE

Nowadays the square's once-private gardens are an open public park – a tranquil place to eat your lunch on a summer's day. Winkley Square is home to a statue of Robert Peel, sculpted by Thomas Duckett Sen, that was unveiled in 1852. The square was reopened in late November 2016 after undergoing a renovation programme and it remains a cherished public open space.

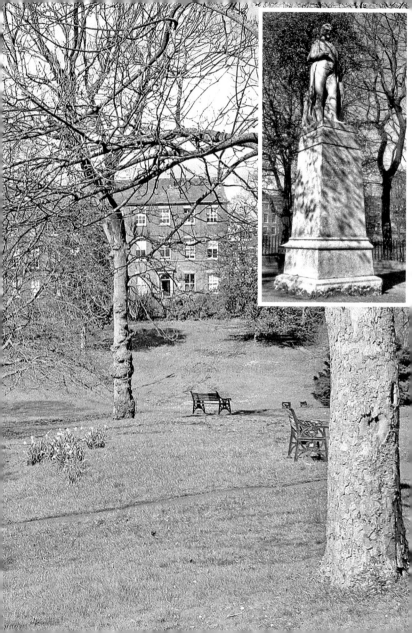

8. WINCKLEY SQUARE FROM THE SOUTH-EAST CORNER

William Cross, inspired by his time in London on legal studies, resolved upon his return to build houses around a public square, as was commonplace in the capital city. In 1799 he erected the first one at the south-east corner of Winckley Street. The land was bought from Thomas Winckley and was part of a meadow known as the Town End Field. The stipulation was that all the houses would be three-storeys high and uniform in appearance. There were to be no factories, no warehouses or shops, and certainly no public houses.

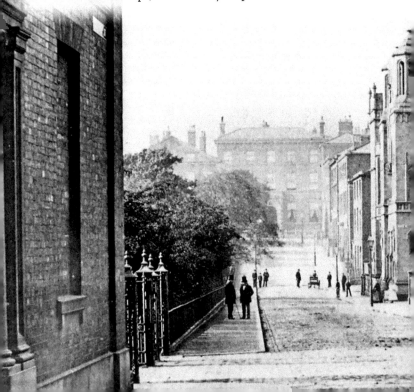

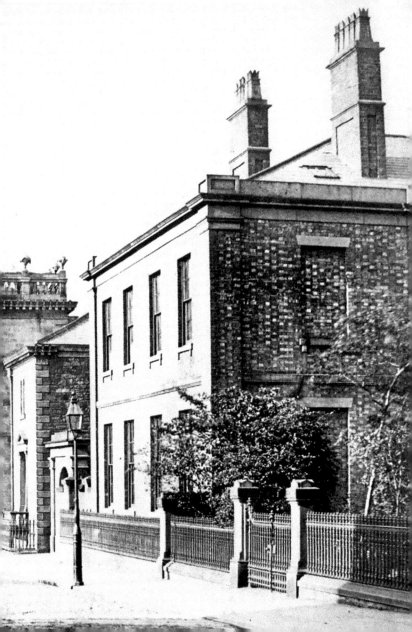

9. WINCKLEY SQUARE FROM THE SOUTH-WEST CORNER

In the nineteenth century, Winckley Square was home to many prominent townsfolk, such as Richard Newsham, Thomas Miller, William Ainsworth, Thomas Batty Addison, Edith Rigby (the suffragette), and Sir Robert Charles Brown (a notable Preston physician). Following his death in 1925, his property was sold at auction to Preston Catholic College for £4,550. During its long history the square has been a significant place for education, with Preston Catholic College, Winckley Square Convent, Preston Park School and Preston Grammar School all educating townsfolk here.

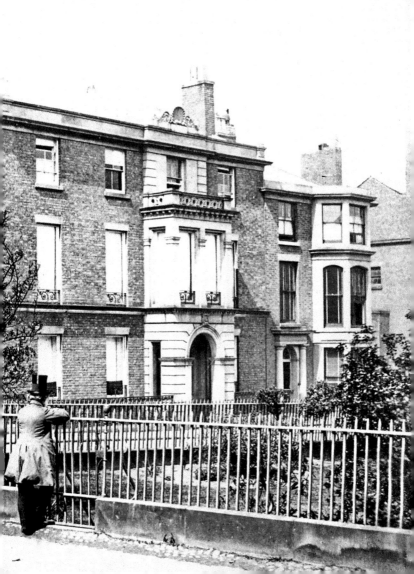

10. AVENHAM PARK

Avenham Park officially opened in 1867. It was once simply Avenham Valley and was developed, like its neighbour Miller Park, during the cotton famine from 1861, those workers made idle from the factory closures being employed to landscape the grounds. In the years that followed additional features were added, including the Japanese Gardens (*see* inset), which were officially opened in November 1936 by Alderman James Harrison of the local bakery firm and Mayor of Preston at the time. The park has many outstanding features including the Belvedere, the Swiss Chalet, the Boer War memorial and a modern-day Pavillion. Walk beneath the Ivy Bridge and you will be in Miller Park.

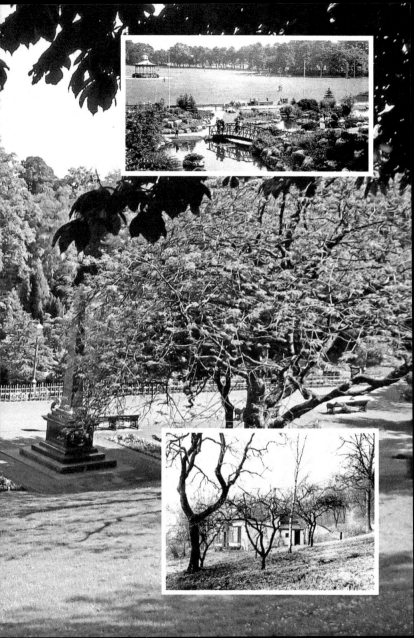

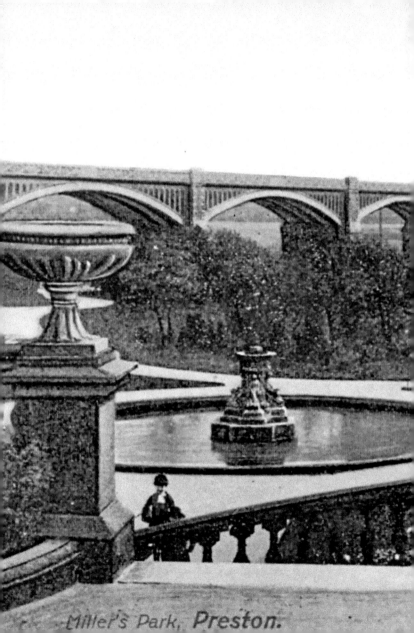

Miller's Park, **Preston.**

11. MILLER PARK

This early postcard view of Miller Park looks towards the River Ribble. Particularly visually impressive at that time was the East Lancashire Railway bridge, which crossed the river. This bridge originally had fifty-three brick arches. Alas, the foundations were weak so the arches were filled in to leave only the embankment on view. The fountain continues to delight and the bridge still stands, although this old Preston to Southport railway route fell victim to the Beeching Plan – closure was announced in 1964. You can still climb the steep stone steps from Avenham Park and walk along the bridge to take an elevated view of the pleasant surrounding.

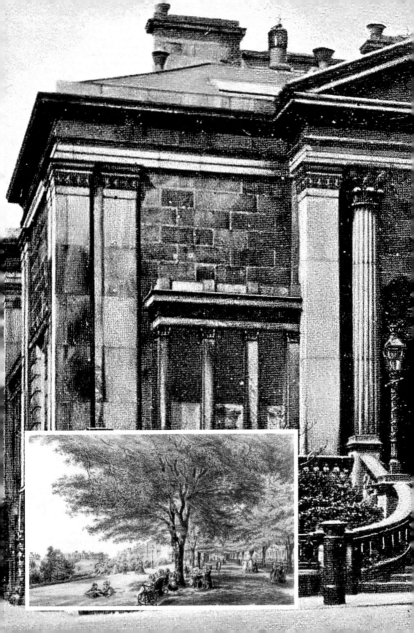

12. AVENHAM WALK

The inset is a nineteenth-century engraving that reflects the beauty of the place, with rows of maturing limes down the centre and to the right of the image. Back in 1697 the Corporation of Preston made plans to create this walk. For just £15 they purchased the land, decreeing that it be planted with trees and made into a gravel walk. The main picture shows the old Harris Institute at the top of the walk, built in 1846–49 to the design of John Welch and costing around £6,000 to construct.

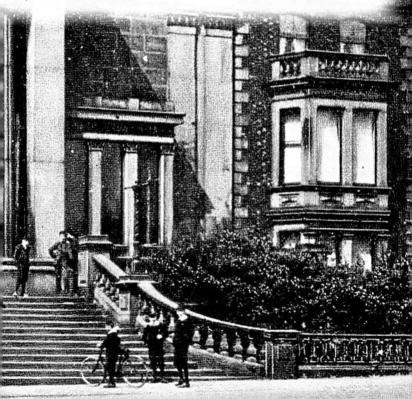

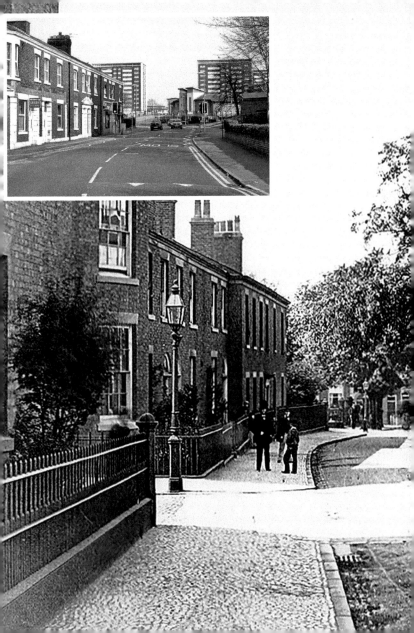

13. AVENHAM LANE

In the 1860s Avenham Lane, as this main image looking towards Ribblesdale Place shows, was a fashionable place to be. The inset images captured further along Avenham Lane, at the junction with Oxford Street, reflect the changing skyline. In the *c.* 1956 picture (*see* inset below) it is dominated by the church towers of St James' Church on the right and in the distance that of St Saviour's. St Saviour's was opened in 1868 and was once described as among the most beautiful churches in town; it closed in 1970. Unfortunately, by the 1980s the church building of St James' was in trouble – porous stonework and dry rot abounding – leading to its closure in 1983. Happily, St James' Church survives in a more modest building on the original site and is part of the parish of The Risen Lord. Today's view shows multistorey apartment blocks: to the left, Richmond House, to the right, Carlisle House.

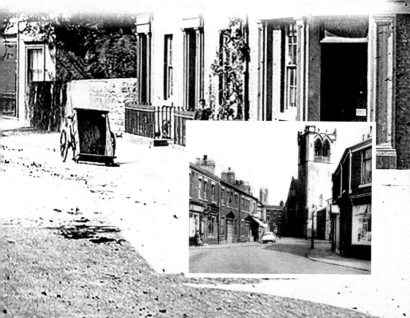

14. ARKWRIGHT HOUSE

In 1728, the Corporation erected the building now known as Arkwright House for the headmaster of the Preston Grammar School to reside there. The building is in Georgian style and constructed in brick with a stuccoed façade and a slate roof. The building's name was given to it in recognition of the significant events that took place there in 1768 when Revd Ellis Henry lived there and Richard Arkwright hired some rooms. Arkwright, one of Preston's most famous sons, and John Kay used the rooms to complete the final trials of their water frame that helped to revolutionise the cotton industry. The building's future looked in doubt but in December 1988 the charity Age Concern came to the rescue and it is now their headquarters and a great credit to their organisation.

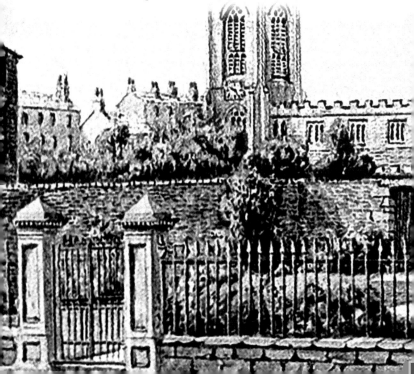

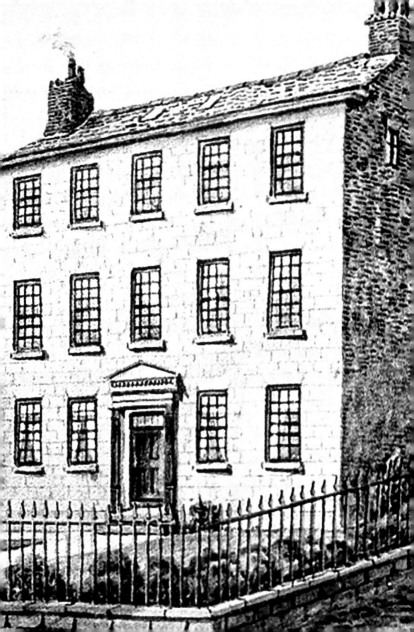

15. ST JOHN'S MINSTER CHURCH

At the top of Stoneygate stands St John's Minster Church, with its frontage on Church Street. The site of the Preston parish church has been hallowed ground since AD 670. The church is proud to declare it has survived the Black Death, the Reformation, the Civil War, the Great Depression and numerous other tribulations. In the past it has been known as St Theobald's and St Wilfred's, before being dedicated to St John the Baptist. The current building dates back to 1854–55, when almost all of the church was pulled down and rebuilt. Thrice married, Canon John Owen Parr was the vicar of Preston while all the rebuilding was taking place – serving the parish from 1840 until his death in 1877. Nicholas Grimshaw, twice guild mayor, and Preston's first police superintendent, Thomas Walton, were among the prominent folk buried here in the nineteenth century. Following the granting of city status to Preston, the parish church underwent much-needed restoration work and was unveiled as St John's Minister in June 2003.

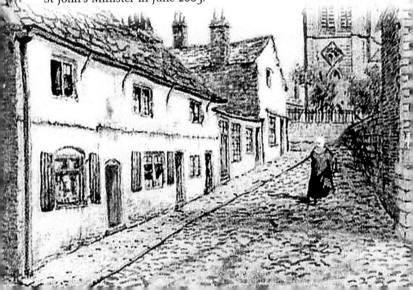

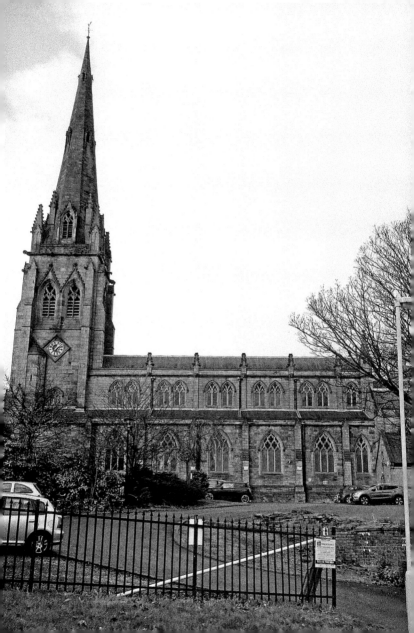

16. LONDON ROAD

This busy thoroughfare, pictured here *c.* 1958, crosses the River Ribble over the present-day Walton Bridge, which was built between 1779 and 1781. The bridge was made wider in around 1936 to cope with increased traffic flow. On the skyline in this image, the tall chimneys can be seen that were part of the Calvert cotton mill complex. The area to the left of London Road was once a vast Preston Corporation refuse dumping ground before it was eventually developed into a running and athletics track. Just before the bridge on the left, the Shawe's Arms public house can be seen.

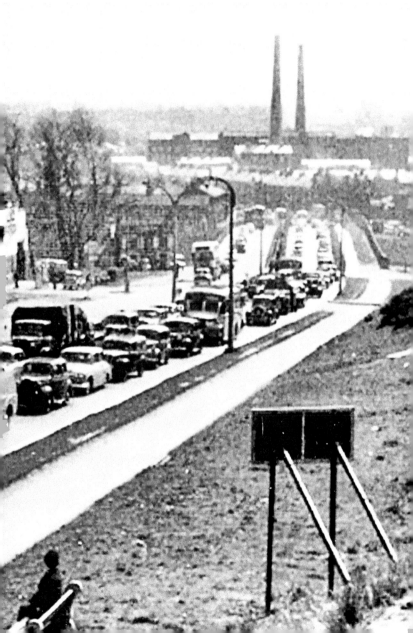

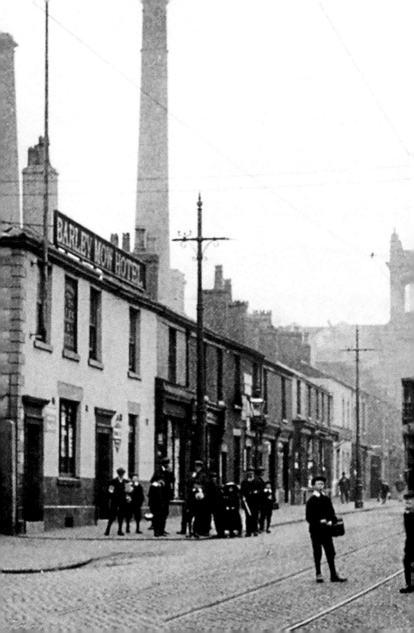

17. NEW HALL LANE

John Horrocks (of cotton fame) was responsible for the development of the densely populated area that became known as 'New Preston' as the New Hall fields were developed. In this image from *c.* 1910, in the foreground to the left, is the Barley Mow Inn, and to the right is the Rosebud Hotel. These are just two of the fourteen public houses between this end and the cemetery gates end of New Hall Lane at the dawn of the twentieth century. The Barley Mow was no longer serving drinks in 1936; the building later spent some time as a police station and then as a recruiting office for soldiers before becoming the Shipsides Marine shop. The Rosebud lingered on until 1988, when it was knocked down along with the nearby streets. Almost centrally placed is the Centenary Mill, which was built to celebrate 100 years of the Horrockses dynasty; building work was completed in 1895. The mill is now filled with apartments and the old offices are now a Travelodge, to the rear of which is the Preston Antique Centre.

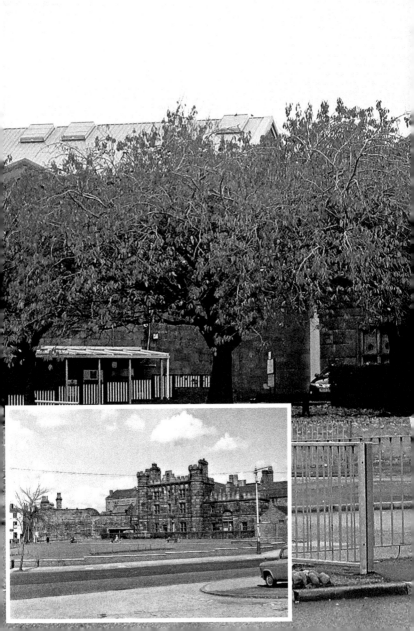

18. HMP PRESTON

HMP Preston was opened in 1789 at the eastern end of Church Street and was named the House of Correction. It was the brainchild of the celebrated philanthropist and prison reformer John Howard. Howard travelled the world, studying different forms of punishment; the Preston project was to be among his last before his death in 1790. The expected demolition of Preston Prison in 1938 never occurred. It had closed in 1931 due to a shortage of prisoners. Prior to the Second World War it became a Civil Defence store and eventually a naval prison. It was due to close again at the end of the war, but an increase in crime led to its reopening as a civil prison. These days it is a Category B local prison.

19. CHURCH STREET, VIEWED FROM LANCASTER ROAD

This view shows, on the left-hand side, Preston Savings Bank, now the Weatherspoons public house known as Twelve Tellers, and alongside it the lavish Empire Theatre, which opened in 1911. To the right is the ancient Bull & Royal Hotel, the place for genteel folk to stay. Following this is the Conservative Working Men's Club and next to that is the Eagle & Child public house, situated at the top of Stoneygate. The Empire Theatre, which became a popular cinema and finally a bingo hall, was knocked down in 1976; currently a restaurant and a Tesco Express with apartments above occupy the site. The buildings to the right remain, although the premises are used for different purposes, except for the Eagle & Child – it was swept away in 1931 making the entrance to Stoneygate much wider.

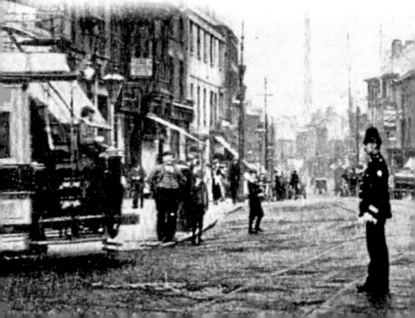

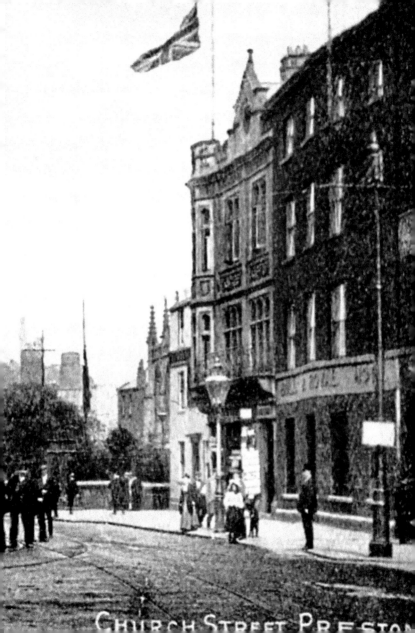

CHURCH STREET PRESTON

20. CHURCH STREET, VIEWED FROM LANCASTER ROAD

It would seem that dentistry was a lucrative business in late nineteenth- century Preston because local dentist Nathaniel Miller had enough of a fortune to invest in the property business. The Miller Arcade, built on a steel structure, still stands on the corner and was the town's first purpose-built shopping centre, opening in 1901. In the inset photograph of the corner of the Miller Arcade, Hayhurst's King's Arms can be seen. Captured on camera is a moment in 1907 as an early electric tram turns into Church Street. At that time Breakall's the brewers was standing on the corner of Lancaster Road, later replaced by Starkie & Co., the outfitter's, who have now given way to Richer Sounds.

If you view the skyline of this Edwardian image you can see the long-gone town hall clock tower and the corner towers on top of Miller Arcade. It is still a busy junction these days, with buses having replaced the trams since 1935.

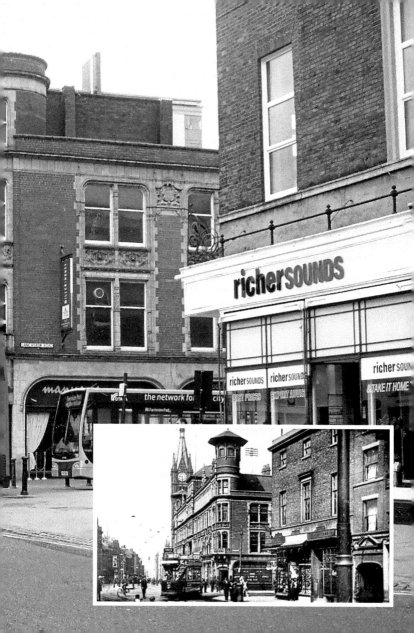

21. LANCASTER ROAD

A busy Lancaster Road, constructed back in 1827, is captured on this photograph from the 1950s. The King Arms, a bus shelter and a zebra crossing are all reminders of a bygone age. Beyond the arcade, the Harris Museum, the Sessions House and the Municipal Building can be seen. Now a taxi rank stands where the bus shelter stood. The Harris Museum building still dominates the skyline. To the right is the Stanley Arms. This inn carried the name Knowsley Arms for a period up until 1972, when it was given a new lease of life with an Edwardian- style renovation and a return to its old name. The Stanley Buildings, also to the right, are still home to a variety of shops and retailers.

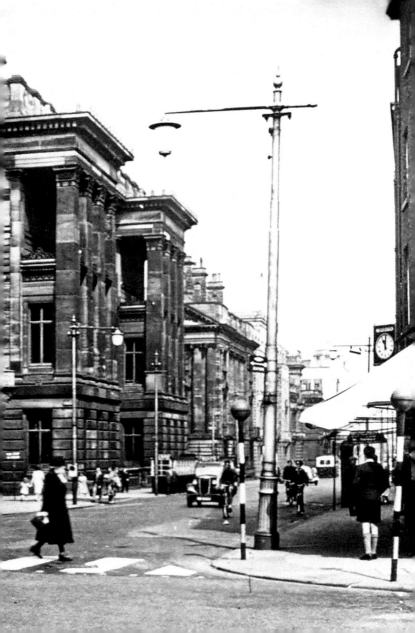

22. CHEAPSIDE

This busy scene from around 1962 shows Cheapside when the once-familiar high street retailers Stead & Simpson, Richards and Stylo were all offering the latest for the fashion conscious. John Collier the tailors had their slogan 'The window to watch'. Amazingly, one building that remains unaltered, just out of view, is the small gable-fronted shop of seventeenth-century origins – the Thomas Yates jeweller's shop. It serves as a reminder of Thomas Yates, who was an award-winning watchmaker and operated from a shop on Friargate until his death 1890. Other familiar names along this stretch of shops in days long gone included Hamilton's the drapers, Coward Brothers the grocers and Freeman, Hardy & Willis, who supplied many a Prestonian with a good pair of boots.

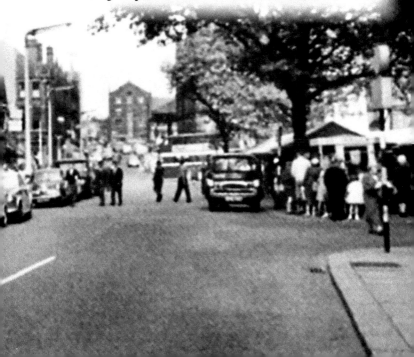

23. MARKET PLACE

This image shows a busy market day in 1936 with stalls spilling over onto Birley Street. The newly built Municipal Buildings can be seen alongside the Sessions House. To the left of the picture is the Central Post Office building, which opened in 1903. In 1987, when it was given a £0.5-million renovation, it was described as the busiest building in town. It was vacated in 2002 when the post office moved to the Urban Exchange Arcade on Theatre Street. To this day the Harris Museum and Library, which officially opened in October 1893, looks resplendent and worth every penny of the £122,000 legacy that Edmund Robert Harris left for its construction. It is hard to imagine now that the Shambles once stood there, where butchers carried out their trade, or that bear- and bull-baiting was commonplace, and delinquents were punished here by means of the pillory.

The Preston cenotaph war memorial recently underwent renovation work and is now a Grade I-listed structure. Designed by Sir Giles Gilbert Scott, it is at the heart of the city and a fitting tribute to those who gave their lives for their country.

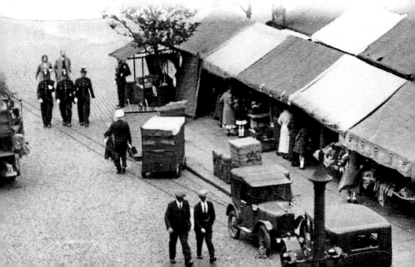

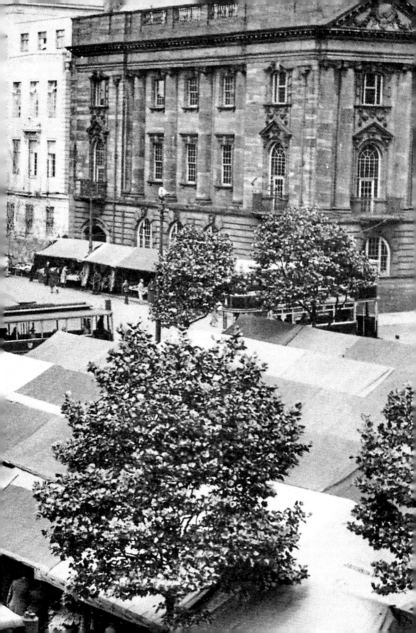

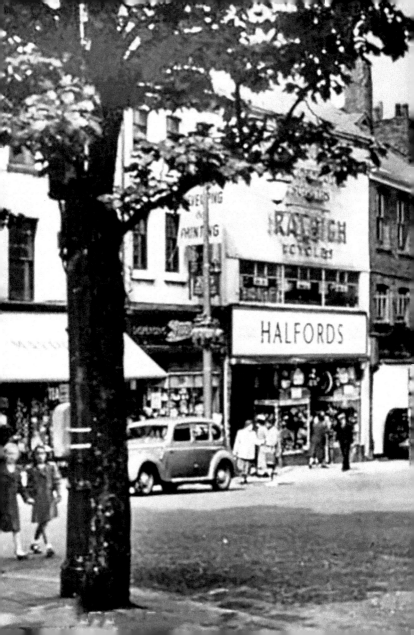

24. FRIARGATE

When this postcard picture was produced *c.* 1956 Friargate was a busy thoroughfare. Up until 1893 the entry to Friargate was very narrow, but the demolition of New Street to the right changed all that. The George Hotel on the corner, built on the site of the old George Music Hall, has had many uses since its hotel days. It had a spell as a Barclays bank and is currently occupied by the bookmaker's William Hill – who would have bet on that! The Tetley's Ale sign on the left is displayed by the once-popular Boar's Head public house, which closed in 1983 to be converted to shop premises. The buildings to the left have all been replaced in the intervening years. We now have raised flowerbeds and gates where the zebra crossing was once necessary, confirming this part of Friargate is relatively traffic-free today.

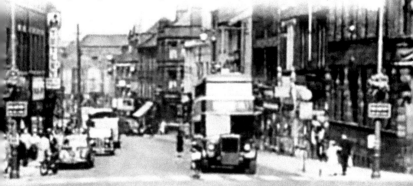

25. PRESTON GUILD HALL

Building of the Guild Hall began back in 1969. A grand opening was planned for the Preston Guild of September 1972, but delays and strikes meant it was unfinished in time. The octagonal building took longer than expected in construction, eventually opening in May 1973. It completely transformed that section of Lancaster Road and, with a 2,000-seat concert hall, a theatre and a shopping arcade beneath, it was a good investment. With the arrival of the new Guild Hall, the imposing Guild Centre high-rise office block soon followed on Lords Walk to outclimb even the nearby Unicentre, being 15 storeys high and 208 feet tall. Businessman Simon Rigby took over the Guild Hall in 2014 and acquired the Guild Centre in mid-2015 – he has ambitious plans for the entire site.

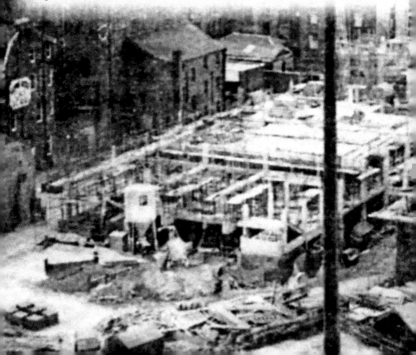

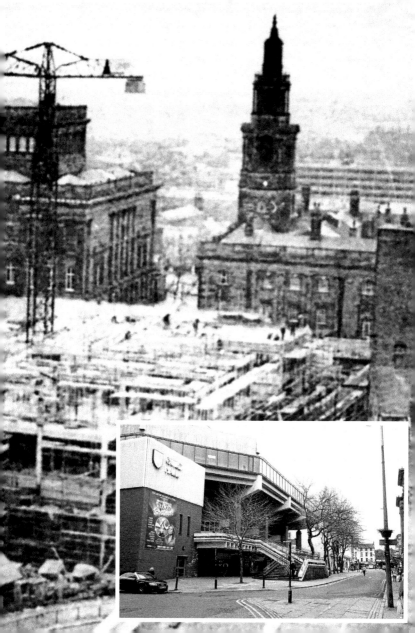

26. PRESTON TOWN HALL

There was a certain optimism about the future in Preston back in 1931, so much so that the local builder Thomas Croft was called upon to prepare a site for the erection of the Municipal Buildings, nestled between the Sessions House and the old Earl Street police station. The building included a council chamber and was officially opened in September 1933, where, besides the many dignitaries, a great crowd gathered. The photograph shows the scene in 1948 when the WRAF were on parade. Eventually, in 1972, the building officially became the town hall; it is the place where civic matters are conducted.

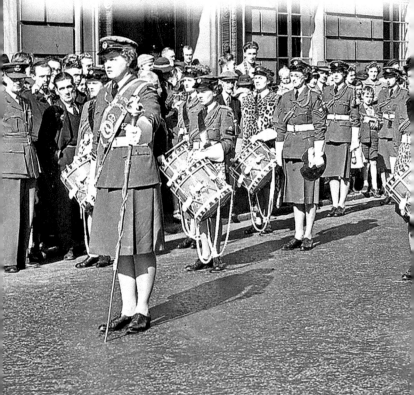

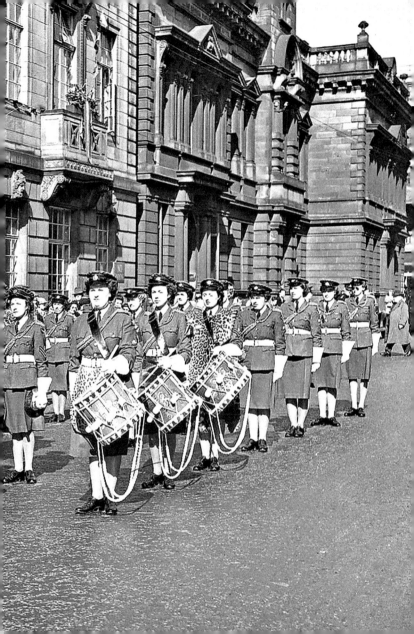

27. CROOKED LANE

Crooked Lane these days no longer resembles the time that the inserted picture shows (1957). Or, indeed, the days of the soup kitchen, shown in the illustration, that provided much-needed food for the famished Preston poor. At the height of the cotton famine, when cotton mills were idle between 1861 and 1864, the old mill shown in the inset image was the depot of the Relief Committee and it was common during the distress to see a long line of haggard, ragged men, women and children, standing patiently outside with jugs in their hands ready to be served with soup, bread and other necessities; a great credit to those who simply asked 'Give us this day our daily bread' and those who provided when starvation was a reality.

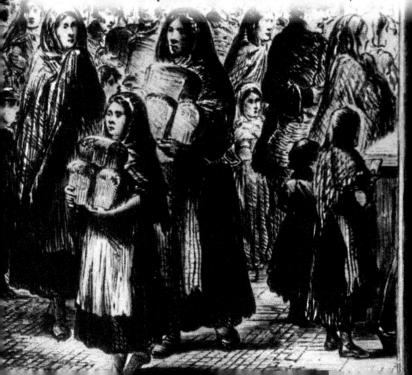

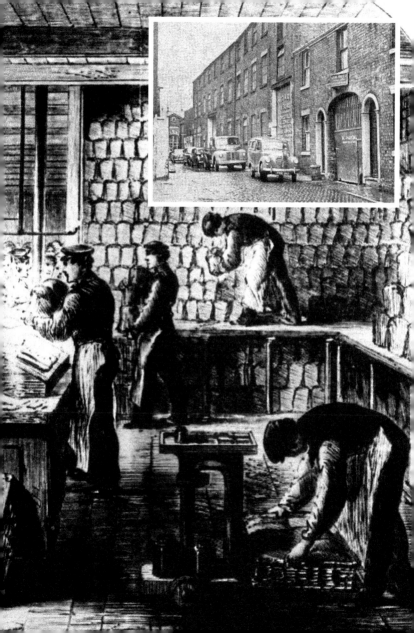

28. PRESTON BUS STATION AND UNICENTRE

Preston Bus Station was used for the first time by the Preston Corporation fleet of buses on Sunday 12 October 1969. It was built on the site of the old fire station and Everton Gardens at a cost of £1 million, with stands for eighty buses and a multistorey car park to the designs of the local firm Building Design Partnership. By October 1970 work was underway on nearby Lords Walk on a multistorey office block development costing £1 million that would be named the Unicentre. Standing at 150 feet, it would become the tallest office block in town. If you wish to climb to the top floor of the bus station, grand views of Preston from all points of the compass will be before you.

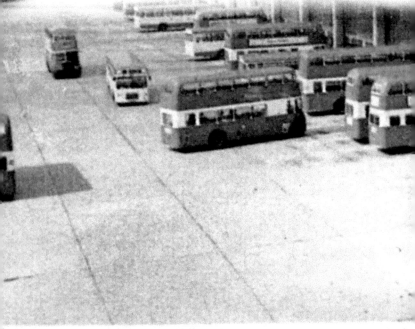

The New Bus Station, Preston (Largest in Britain).

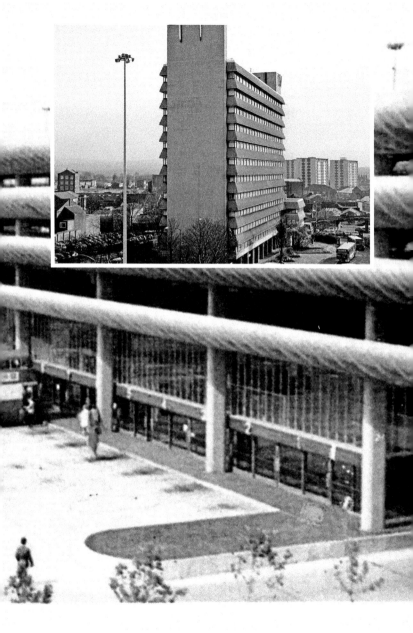

29. COVERED MARKET

The area formerly known as the Orchard, where cows grazed among the trees, was selected for the construction of the covered market. It turned out to be a protracted affair. The contract was originally given to Joseph Clayton of the Soho Foundry and during construction the roof collapsed in August 1870, leaving a tangled mass of ironwork. The work was finally completed in 1875 after William Allsup stepped forward to complete the task in reward for £9,126. The Preston folk were brought up on market trading, as the 1961 image here suggests, with the happy families busily shopping. Allsup's work has certainly stood the test of time; the Covered Market still stands and is at present undergoing renovation work as part of the intended transformation of the area. The indoor market that stands alongside is earmarked for demolition with lavish plans for a cinema, restaurants and a plaza.

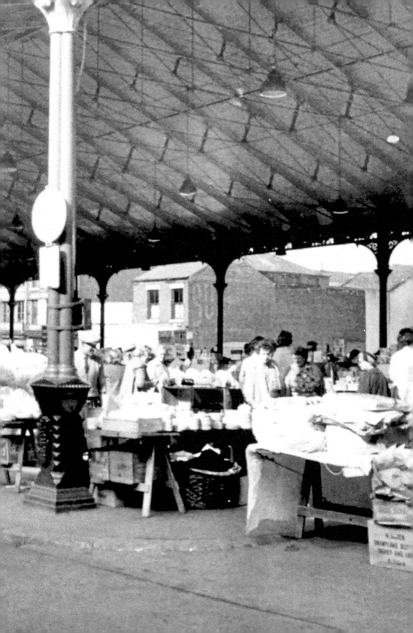

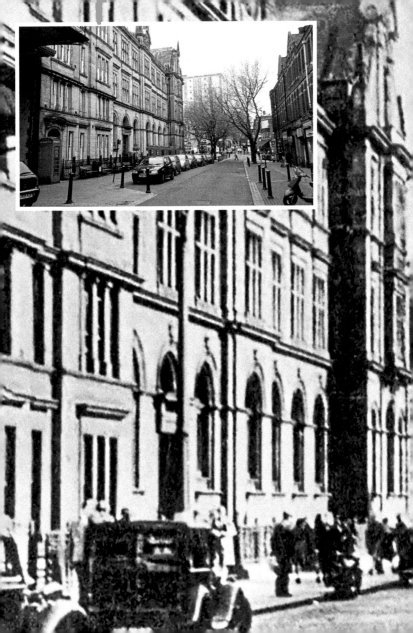

30. MARKET STREET

The thing about Market Street is that it takes you from the Market Place to the Covered Market – so it is aptly named. It is probably most famous for the row of red telephone boxes alongside the old Central Post Office building, now called Deans Court Chambers, and the red Victorian postbox on the corner of Friargate. In this *c.* 1935 image there is only one telephone box in the left-hand corner – there are now nine. In this age of mobile phones, we have done well to preserve them. The old Gothic town hall can clearly be seen, along with the Maypole store sign on Cheapside. These days the Cubic occupies the site of the old town hall.

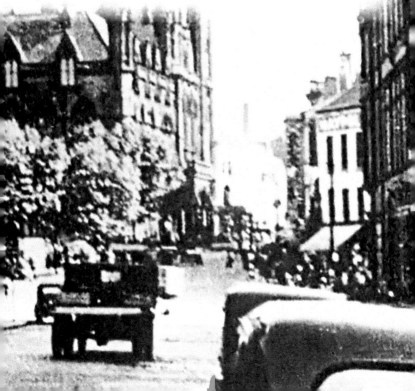

31. ORCHARD STREET

Not so many years ago it was cheese, butchers and haberdashry shops that greeted you on Orchard Street, nowadays it is fast food, betting and charity shops that greet you. Lang's Map of 1774 clearly shows the establishment of the lane that would later become Orchard Street, with dwellings on either side of the thoroughfare and the vastness of Colley's Orchard with an abundance of trees – all precious land that would be developed during the following century. The street we are familiar with nowadays was constructed by around 1836.

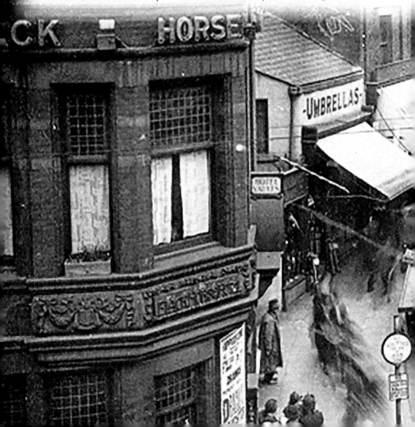

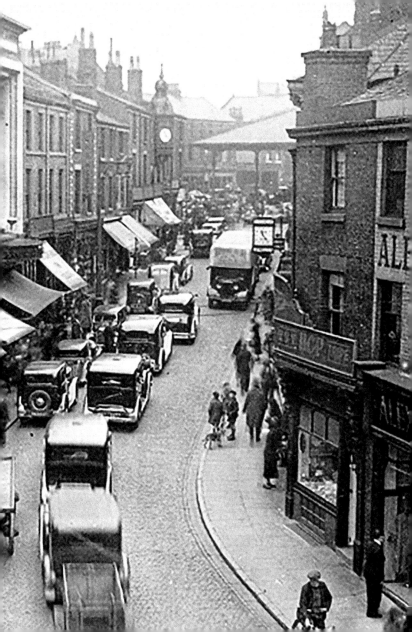

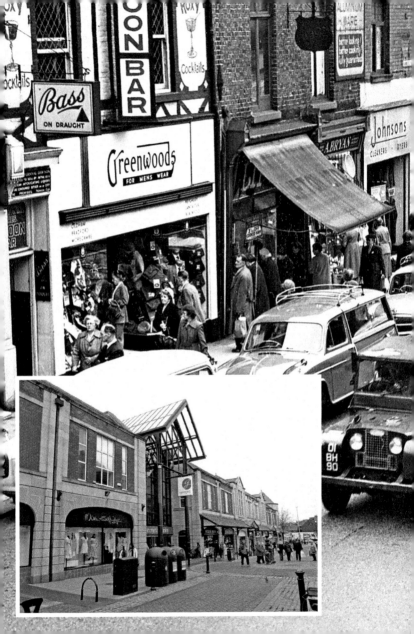

32. FRIARGATE AND ST GEORGE'S SHOPPING CENTRE

This busy Friargate street scene of 1957 would be completely transformed in the decades ahead. The Friargate entrance to the new St George's Shopping Centre contributed to that. The centre was situated between the main thoroughfares of Fishergate and Friargate, and built on the area known as Bamber's Yard. St George's opened for business in November 1964 with around thirty of the planned 120 units welcoming customers who climbed the spiral staircase to the upper floor. Costing over £5 million to construct, it was officially opened by Mayor Alderman William Beckett in March 1966 – by which time it was a thriving concern. The centre had a roof added in 1981 when it was refurbished and in 1999 it was completely transformed once more, standing three-storeys high it carried the name 'The Mall'. Ownership changed hands again in 2010 for £87 million and it reverted to its original name.

33. CHAPEL OF ST GEORGE

The historical St George's Chapel on Lune Street was built in 1725. The chapel was expanded in 1799, encased in stone in 1843–44, a chancel was added by Edmund Sharpe in 1848, and the church was remodelled in 1884 at a cost of £6,000. It is built in sandstone with a slate roof and is Romanesque in style. The church consists of a nave, aisles, transepts, a chancel and a porch with a tower. Among those buried here are Samuel Horrocks, a former MP for Preston and cotton manufacturer, and Dr Richard Shepherd, twice mayor of Preston, who donated his extensive library of books to the town. The person who will be forever associated with this chapel is Revd Robert Harris, the incumbent of St George's for sixty-four years. On Christmas Day 1861, in the midst of the 'cotton famine', he gave a passionate sermon for parishioners to rally against the bitter strife. It was to be the final address from the aged patriarch who died days later, aged ninety-eight.

34. THE ASSEMBLY ON LUNE STREET

This building is, without doubt, one of the most remembered buildings in Preston. Older folk will recall it during the years of decline before the rear portion was swept away in 1989. Likewise, the memory of those great events that had taken place therein still linger. It was actually opened in 1824 as the Corn Exchange and served many purposes, including being used by local fairs and markets to display their wares. During 1881–82 it was much altered and transformed into the Public Hall, a place for large public gatherings and musical entertainment. The Preston Corporation planned to spend £7,000 on the upgrade, but in the end spent upwards of £16,000. Great speakers, great musicians and significant events have marked its history. Local builders Conlon were involved in the excellent renovation of the front portion and it is nowadays a popular public house called The Assembly. With the statue of the Lune Street Riot of August 1842 at the front, it remains a focal point and a place for gatherings.

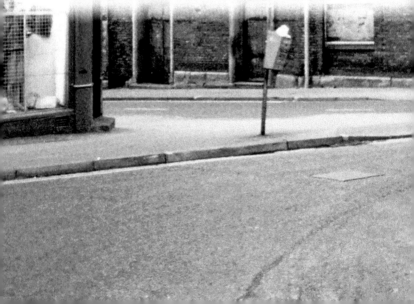

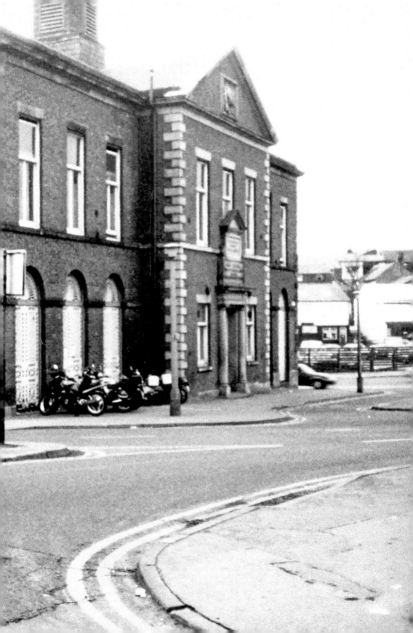

35. FRIARGATE FROM THE RINGWAY

In 1966, the mayor of Preston, Joseph Holden, dug the first shovel full of rubble to get the construction of the inner ring road underway. By the time it was finished part of Lune Street would be swept away. The Old Black Bull would survive the cull, although the premises to its right would be knocked down. In fact, this inn has prospered, having now extended and taken over the adjoining property that was the Dallas Inman gallery. Generally, the buildings to the left have survived, including the recently renovated Dog & Partridge, close to Hill Street, although those up to the still-cobbled Union Street did not.

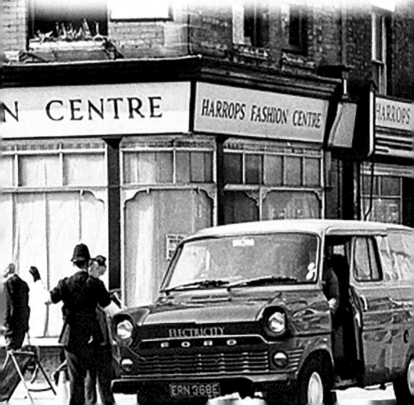

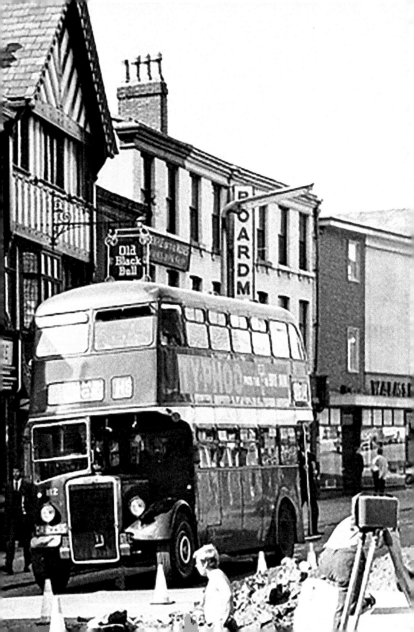

36. FRIARGATE BROW AND ST MARY'S CHURCH

Upon Friargate Brow, hidden behind the shops, you will come across a car park where the Roman Catholic St Mary's Church once stood and where a statue reminds us of past times. From 1761 this ground was home to a chapel of worship. The original chapel was ransacked by a riotous mob in 1768, eventually closed for a while following the erection of St Wilfred's, reopened in 1814, was extended in 1856, struck by fire in 1967, and then finally closed in 1990 due to a dwindling congregation.

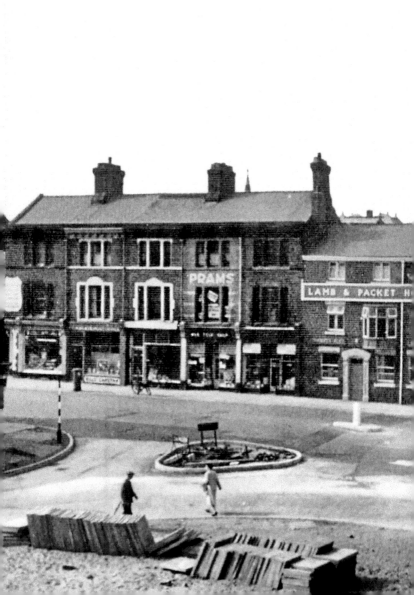

37. FYLDE ROAD ROUNDABOUT

In 1962, construction work was well advanced on the roundabout where Friargate, Walker Street, Adelphi Street, Fylde Road and Corporation Street all converge. In the distance to the right the properties along Kendal Street can be seen, soon to be knocked down, including the original Fylde Tavern and the Star Cinema. On the skyline, smoke billows from the chimneys of Penwortham Power Station. The Lamb & Packet Hotel still holds pride of place at the bottom of Friargate. It derives its name from the Lamb in the coat of arms of Preston and from the days when the Packet boat service ran along the nearby canal. Back in 1822, the Preston Botanical Society met regularly within the inn. The adjoining terrace of shops remain in business, although the goods on offer have changed significantly.

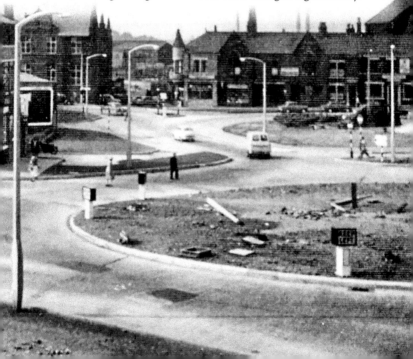

38. ST PETER'S CHURCH

The foundation stone of St Peter's Church was laid in Guild Week 1822 and eventually, at a cost of £7,000, the Gothic structure was completed in 1825, surrounded by open fields. This church began to benefit from the building up of the Adelphi area and in 1852 the tower and the spire were added – paid for with a £1,000 bequest from Thomas German, former mill owner and mayor of Preston. Several members of the Temperance Movement are buried here, including Richard 'Dicky' Turner who was credited with being the first to utter the word 'teetotal'. It was closed in 1973 as a church and became the St Peter's Art Centre within the UCLAN concourse.

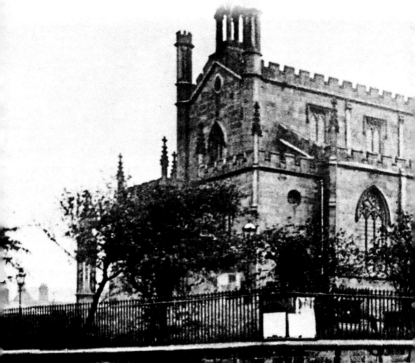

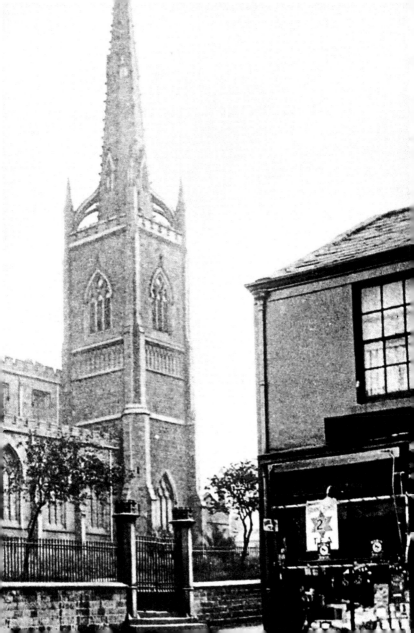

39. ST WALBURGE'S RC CHURCH

This Gothic-styled church has been at the heart of the Roman Catholic community in Preston since it was built during 1850–54 to the design of Joseph Hansom – he of Hansom cab fame. No less than four bishops attended the opening ceremony in August 1854, no doubt keen to see that the £15,000 investment had been well spent. By 1867 both the tower and the landmark spire of limestone had been completed, reaching 314 feet and 6 inches into the sky. As long ago as 1293 a leper hospital dedicated to Mary Magdalene had been in the Maudland area. Franciscan monks were familiar inhabitants of the town. The image shows a backdrop of cotton mills, factories and terraced homes from where the Catholics flocked to divine worship in Preston's early days, inspired by Father Thomas Weston, who was the driving force behind the building of the church and who died in November 1867. The nearby street from which the church is entered carries the name of Weston Street to remember Father Weston and his great contribution.

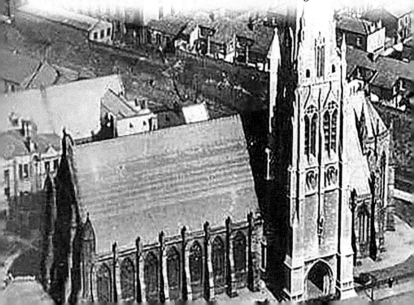

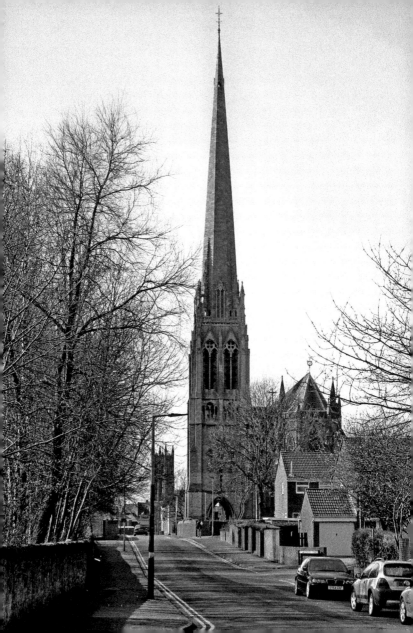

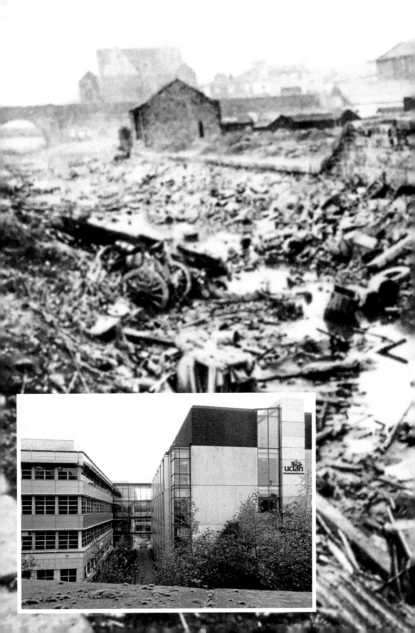

40. SITE OF THE LANCASTER CANAL AT MAUDLAND

It is hard to imagine nowadays that the Lancaster Canal, which terminates at Tulketh Brow, used to terminate at the rear of the old Corn Exchange in the heart of the town. It is possible, to a certain extent, to trace the line of the canal these days, although the growth of the UCLAN campus makes it difficult. This image shows the drained canal looking towards Maudland Road, beneath which the canal flowed. That stretch of canal had become a dumping ground for all manner of things – any old iron, indeed! Nowadays the latest UCLAN buildings stand where canal boats once sailed.

41. UNIVERSITY OF CENTRAL LANCASHIRE

Preston was rightly proud when the new Harris Institute Technical College was erected on Corporation Street in late Victorian days. It had been funded thanks to the generosity of the late Edmund Robert Harris and was officially opened by the Earl of Derby in 1899. The roots of this educational establishment go back to the old 'Institution for the Diffusion of Knowledge'. Little could one have imagined back then that this building, with the Lancaster Canal at its rear, would be the heart of a sprawling university complex that has devoured much of the land around it in the intervening years. Following on from its days as the Harris College, it became the Preston Polytechnic in 1973, then the Lancashire Polytechnic in 1984, before taking the grand title of the University of Central Lancashire in 1992.

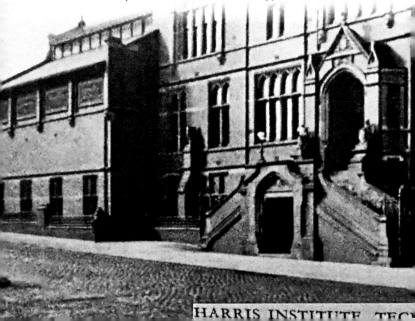

HARRIS INSTITUTE TEC

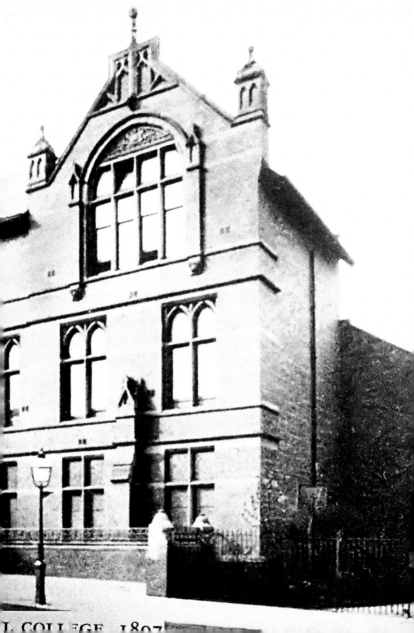

L COLLEGE 1897

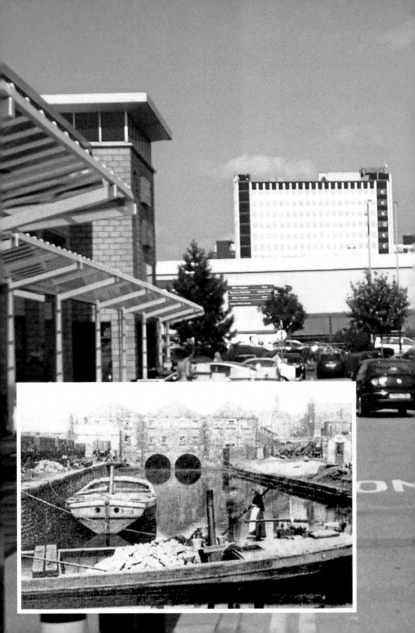

42. PRESTON CANAL BASIN

In 1798, canal communication between Preston and Tewitfield by way of Lancaster was established, being extended to Kendal later. During the Preston Guild of 1822, a packet boat went twice daily to Lancaster. Those days of pleasure boat travel were most inviting for those not in a hurry. The inset photograph, from around 1896, shows the row of warehouse buildings, behind which is the rear of the public hall. The canal, noted for its carrying of coal and limestone, was by this time being overtaken by the railway for transporting goods. After the Second World War, the basin was gradually filled in. There is no longer any trace of those canal days; a shopping centre, Aldi store and a car park occupies the site.

43. CORPORATION STREET

This street, which goes from Fishergate to the Fylde Street roundabout, remains a significant highway for traffic despite being split into two by the ringway. It is rush hour in this image; a policeman on point duty halts the flow of traffic as a bus advertising Capstan cigarettes turns off Fishergate. The old Victoria Buildings on the right, which were home to Loxhams Motors, have been replaced, although the old Caledonian Insurance building remains with different tenants. These days it is a controversial roundabout instead of traffic lights and a zebra crossing.

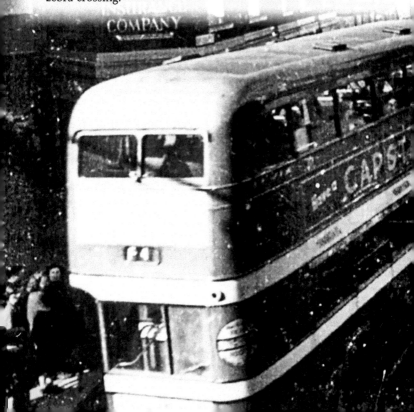

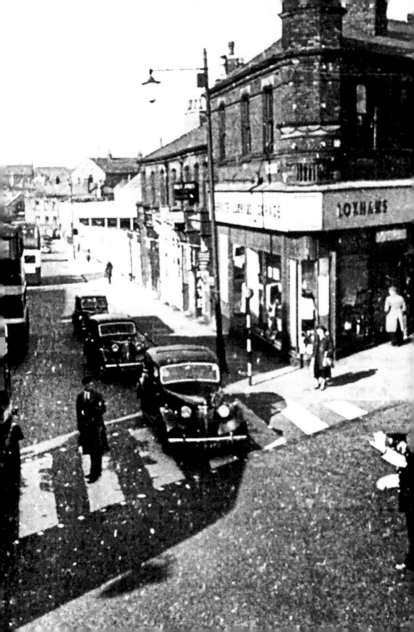

44. THE QUEEN'S BUILDINGS AND FISHERGATE SHOPPING CENTRE

At the top of Corporation Street is the entrance to the Fishergate Shopping Centre, a development that had spelt the end for the properties known as the Queen's Buildings; a consequence of building the Fishergate Shopping Centre being that numerous properties on Fishergate and Butler Street were reduced to rubble, including the old Butler Street Goods Yard. As the Queens Hotel and the adjoining terrace of shops were demolished, only one familiar building would remain – the Railway Hotel on Butler Street, which was extended. Work got underway in 1985 for this shopping centre close to the Preston railway station. Charterhall Properties were the developers, Scottish Amicable acquired the site in 1988 and by 1995 it was valued at £27 million, with Debenhams and Littlewoods the prime retailers. By 2004 plans were drawn up to replace the 'dated and shabby' gateway entrance on Fishergate with the modern and attractive entrance that adorns it today.

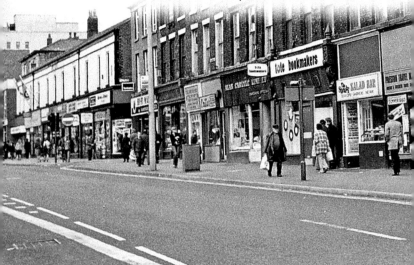

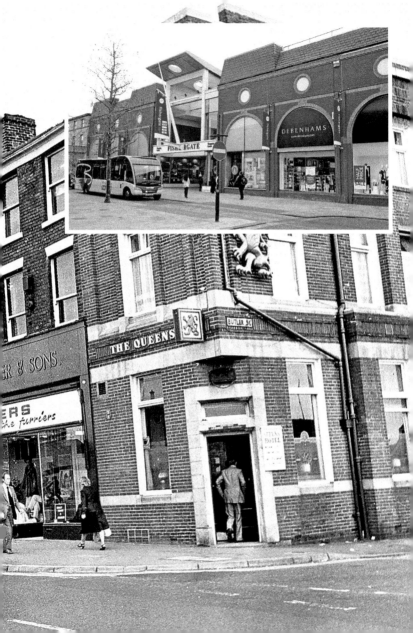

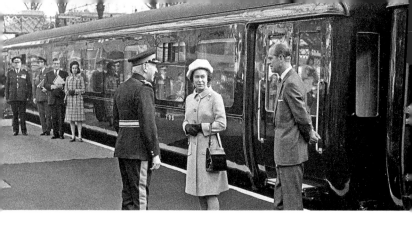

45. PRESTON CENTRAL RAILWAY STATION

Erected by Messrs Cooper and Tullis, and formally opened in July 1880, Preston Central railway station remains at the heart of the railway system. The new station, costing £250,000, was described at the time as one of the finest in existence. It incorporated six lines running through the station onto the platforms, and on the western side four sets of rails for goods trains and shunting purposes. A generally spacious place, the station has had many distinguished visitors down the years, including Elizabeth II in 1974 (shown here) when the London to Glasgow electrified railway lines officially opened, and Queen Victoria who had lunch on one occasion. Even the eminent Prime Minister Gladstone thought it a worthy place to deliver a speech. It was also a familiar place to catch a glimpse of Preston North End's Invincible football team as they journeyed regularly by rail. The steam engines made way for the diesel engines and electrification of the rails followed. It seems though that the golden age of steam still lingers on, with the occasional visit from a smoke-billowing steam engine to delight local steam enthusiasts. As for our trail, we are at journey's end...